A Picture Book of Tropical Fish

Copyright ©A Bee's Life Press All Rights Reserved

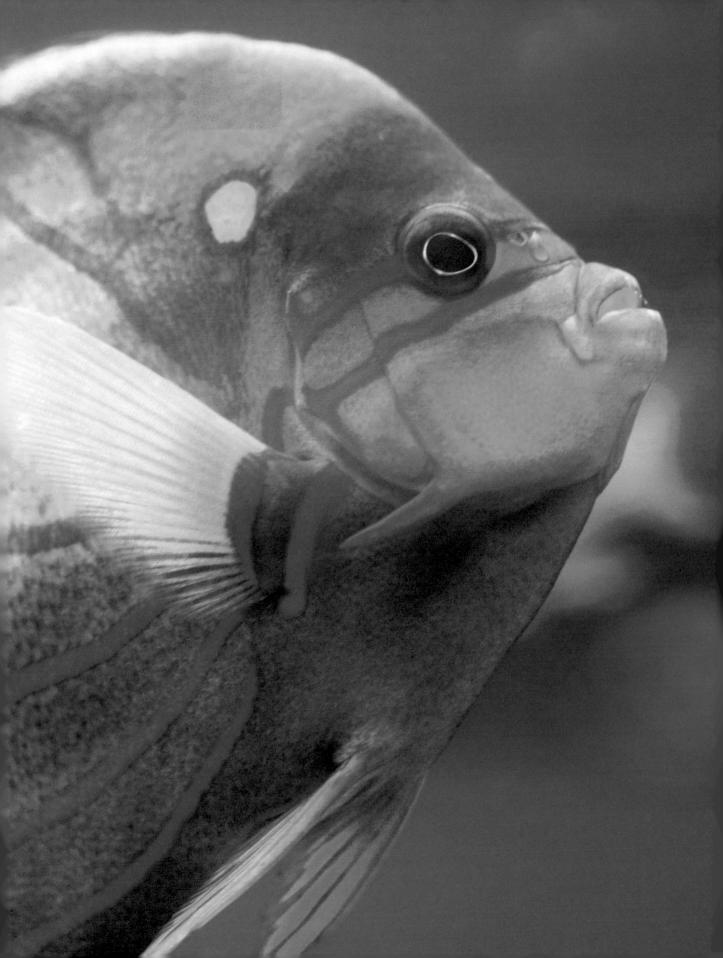

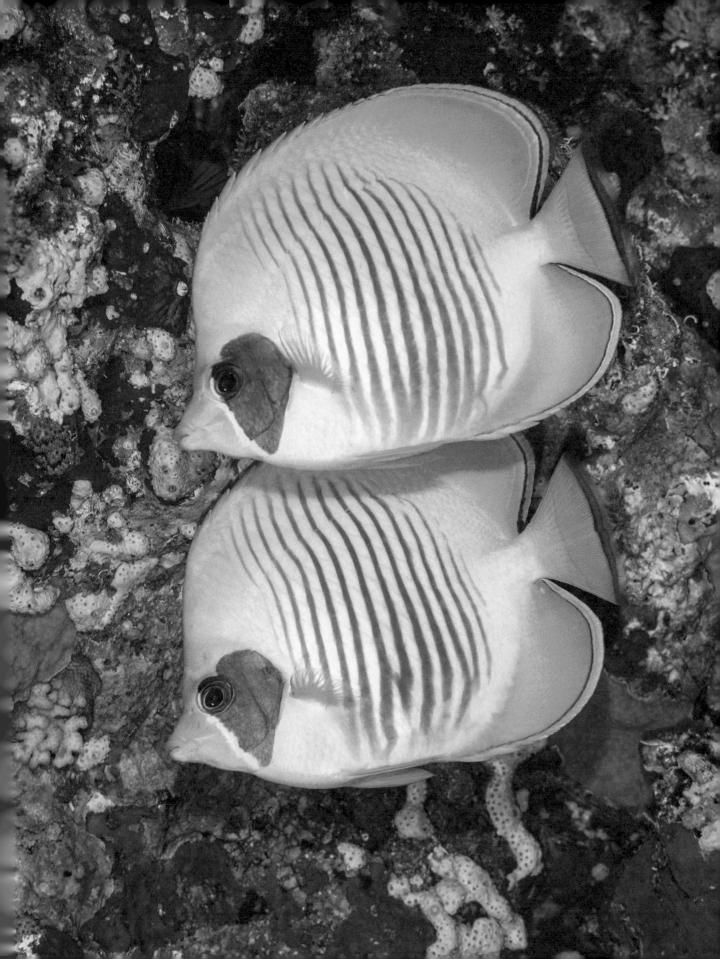

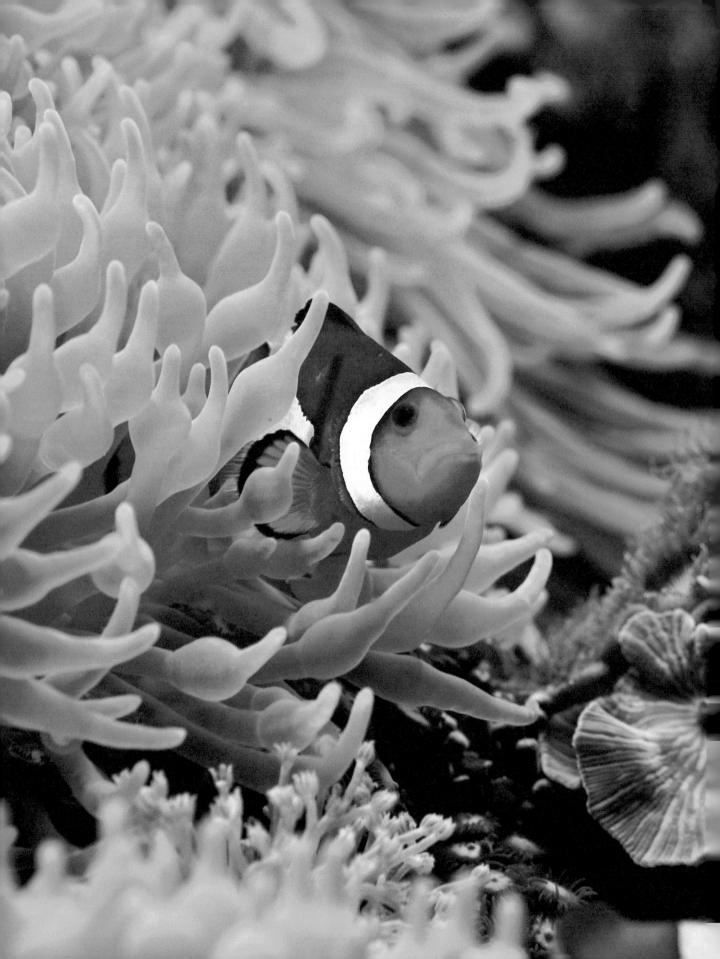

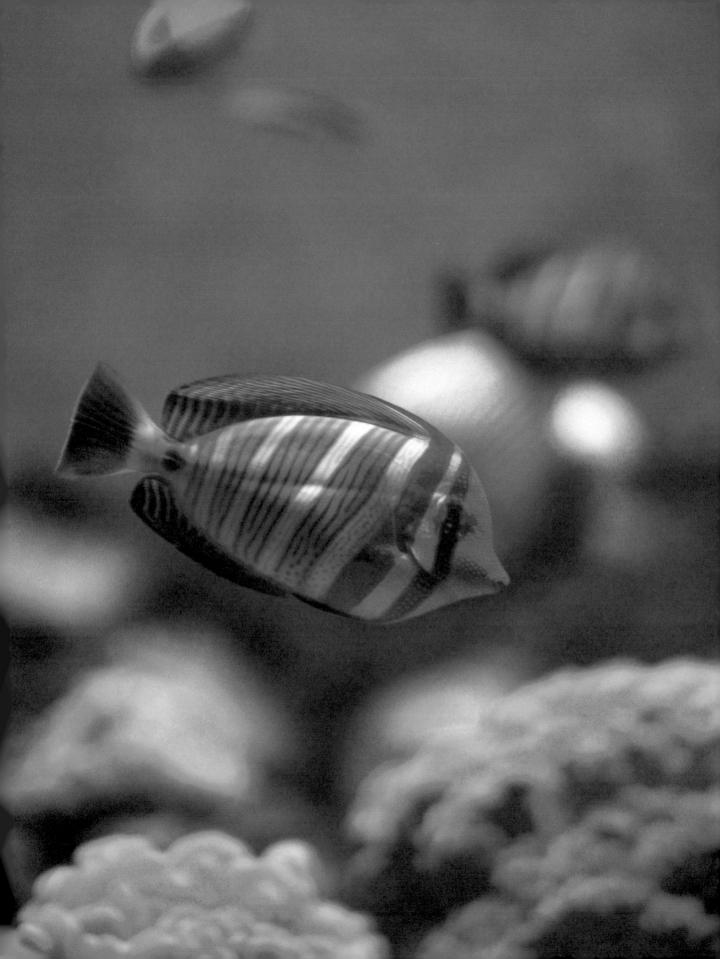

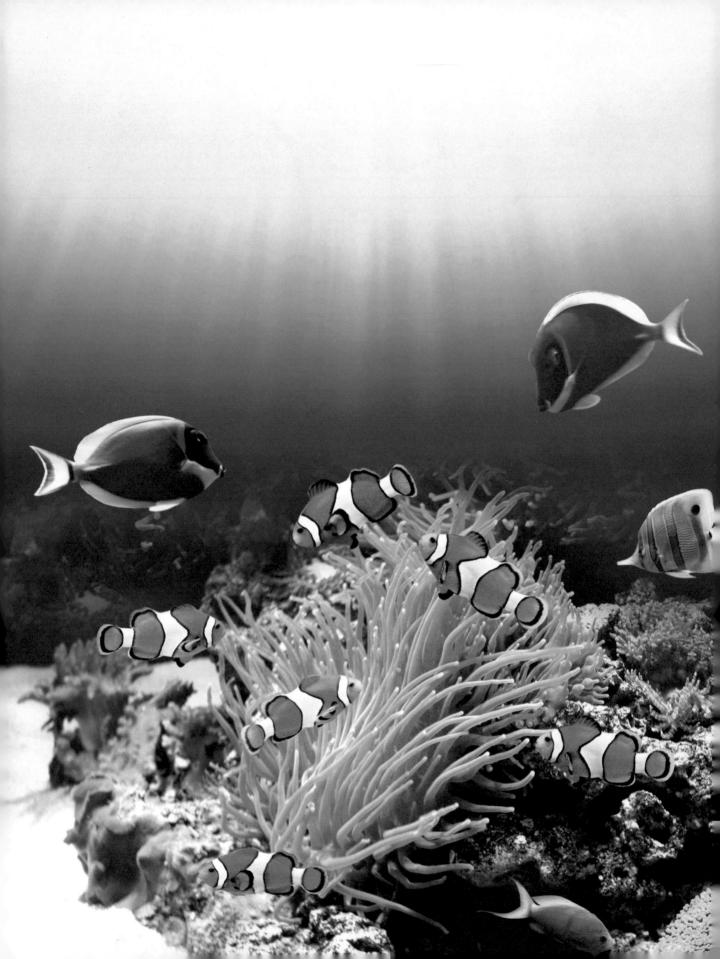

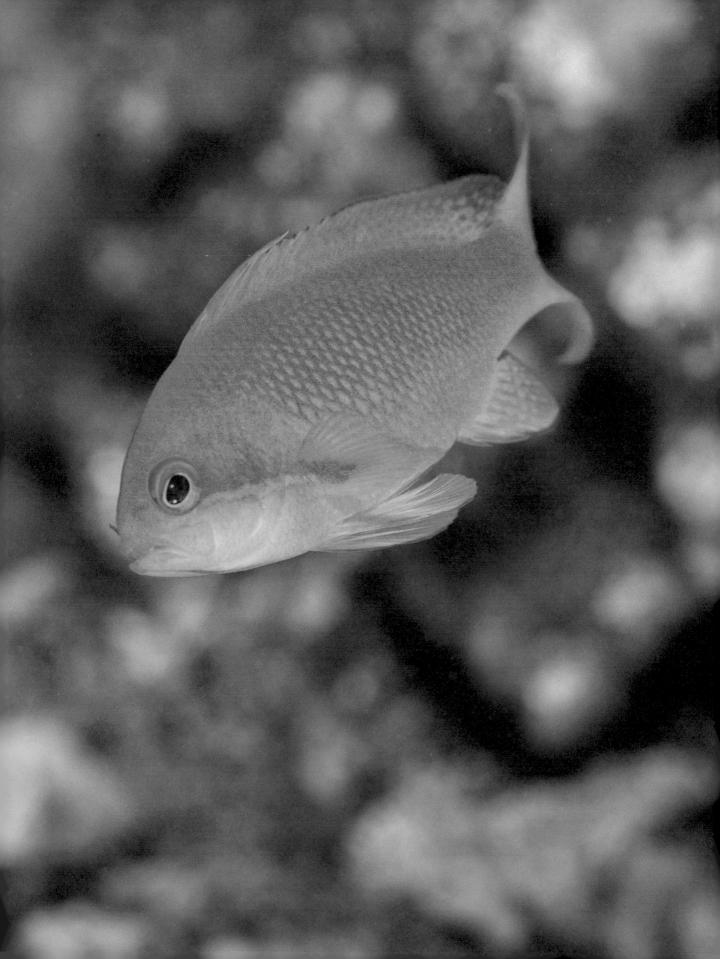

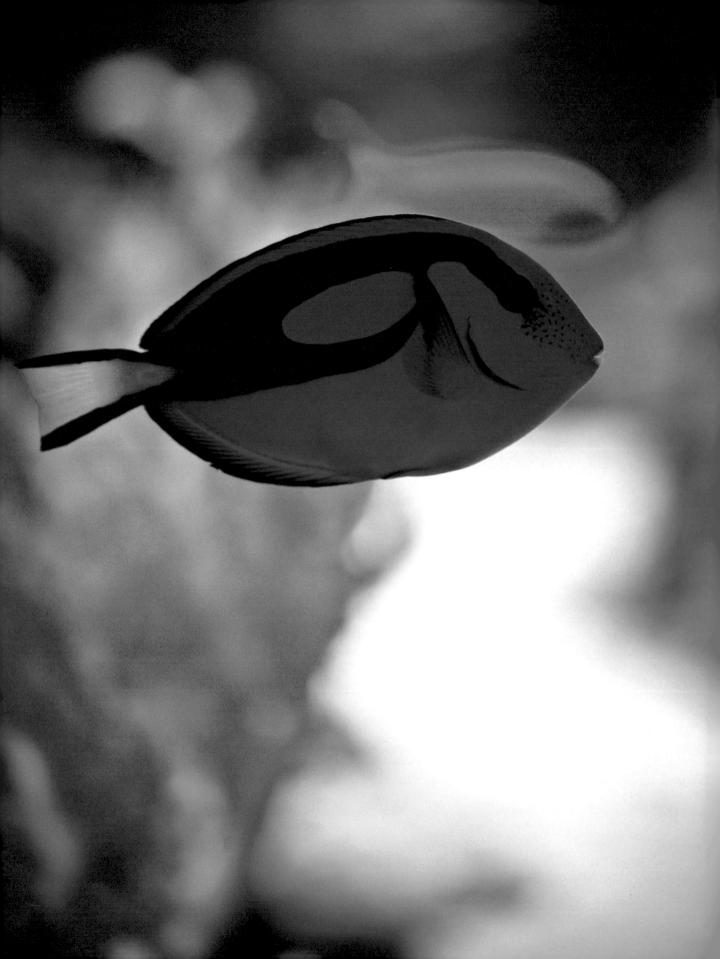

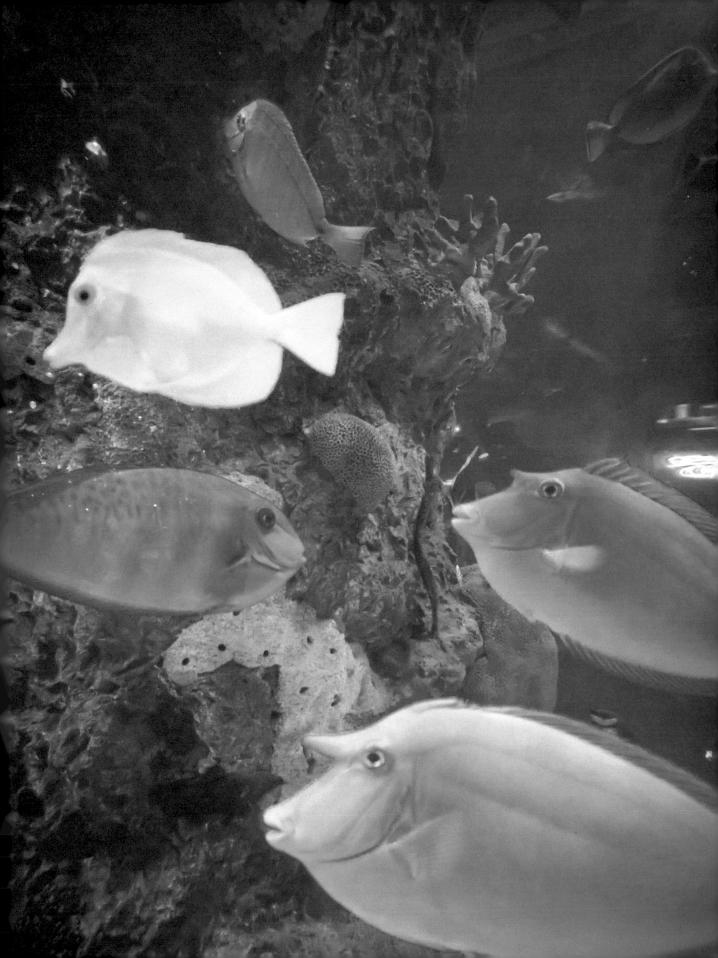

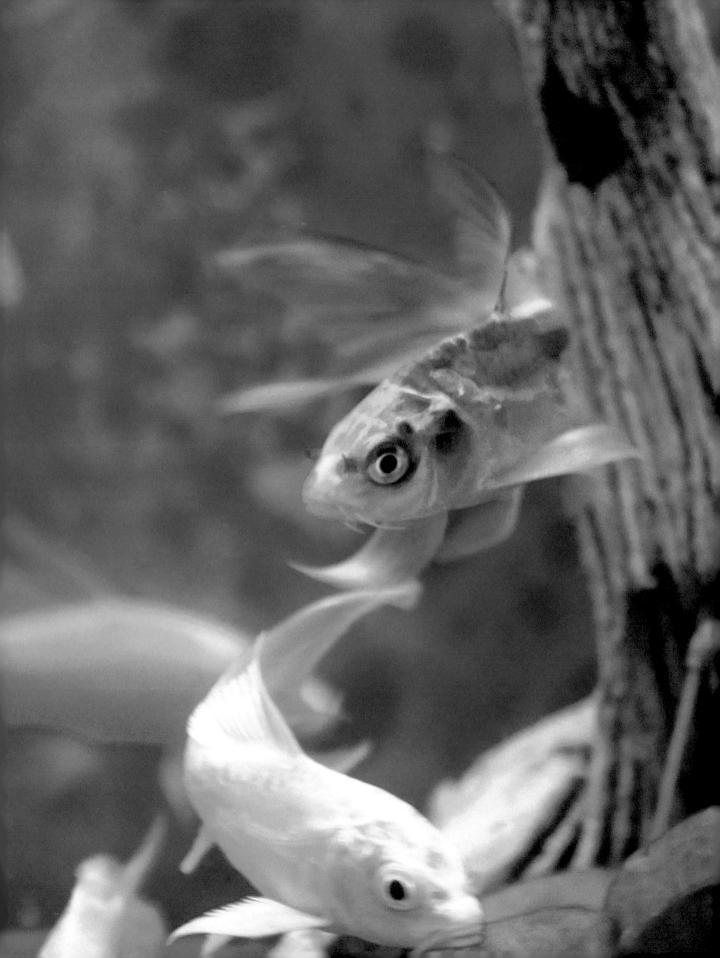

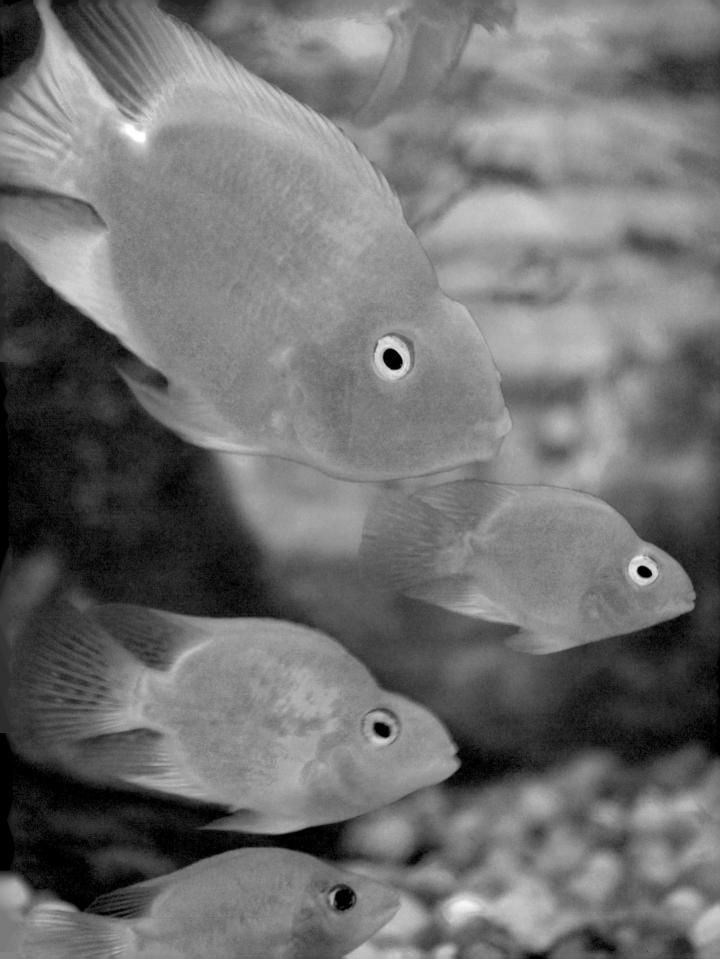

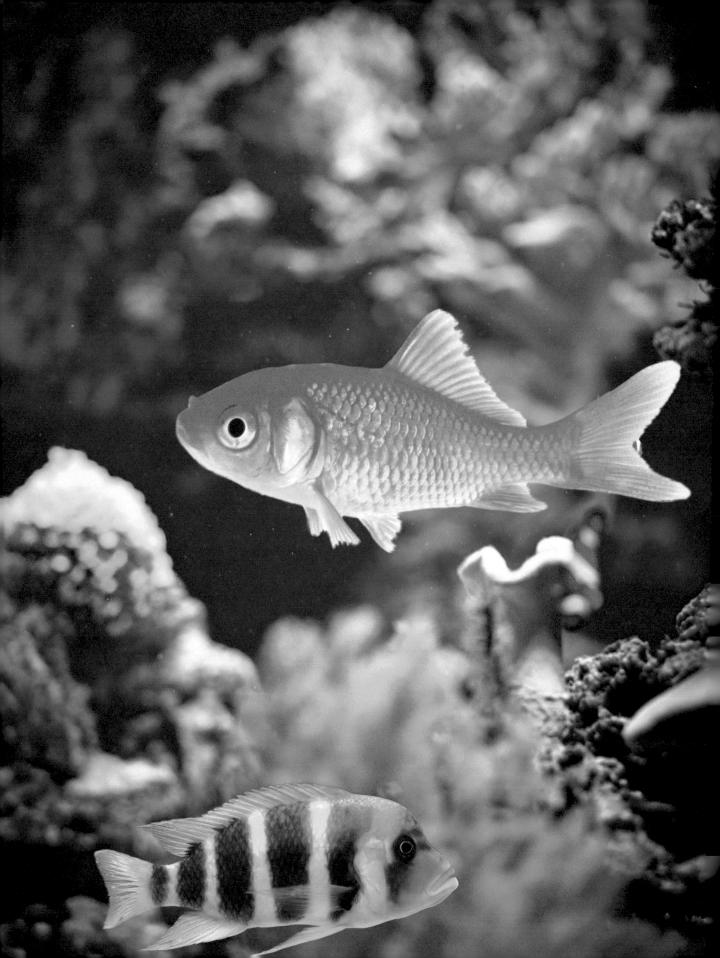

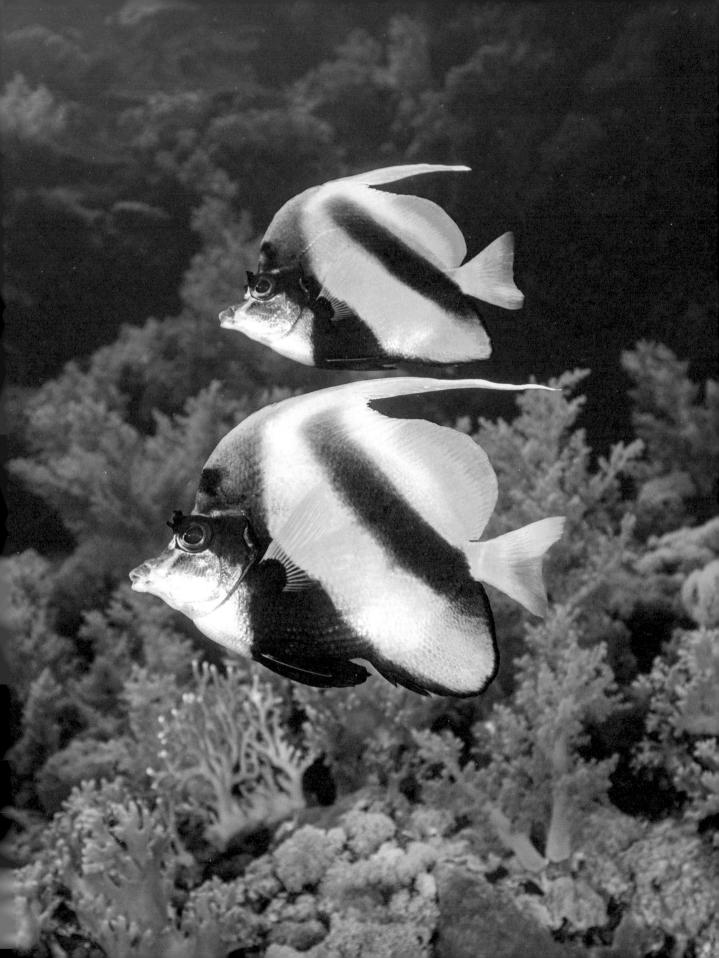

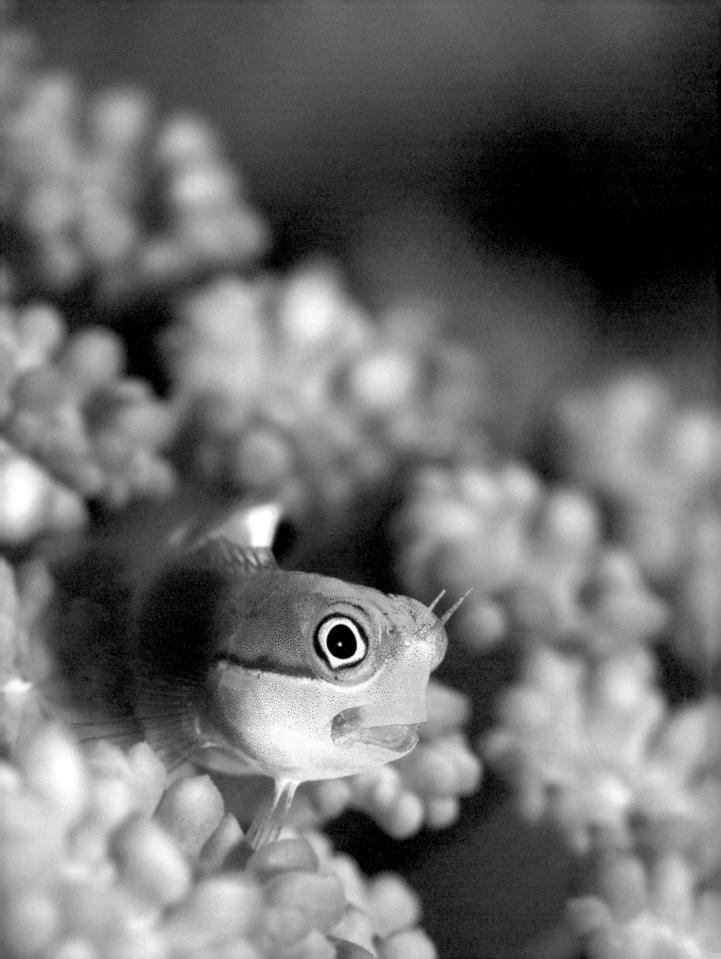

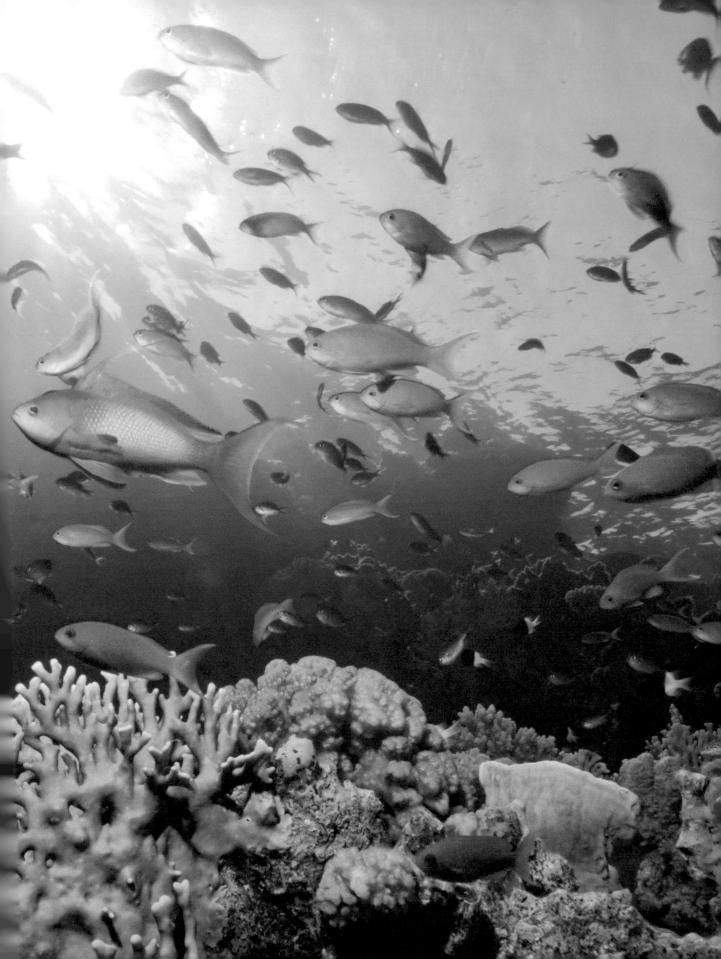

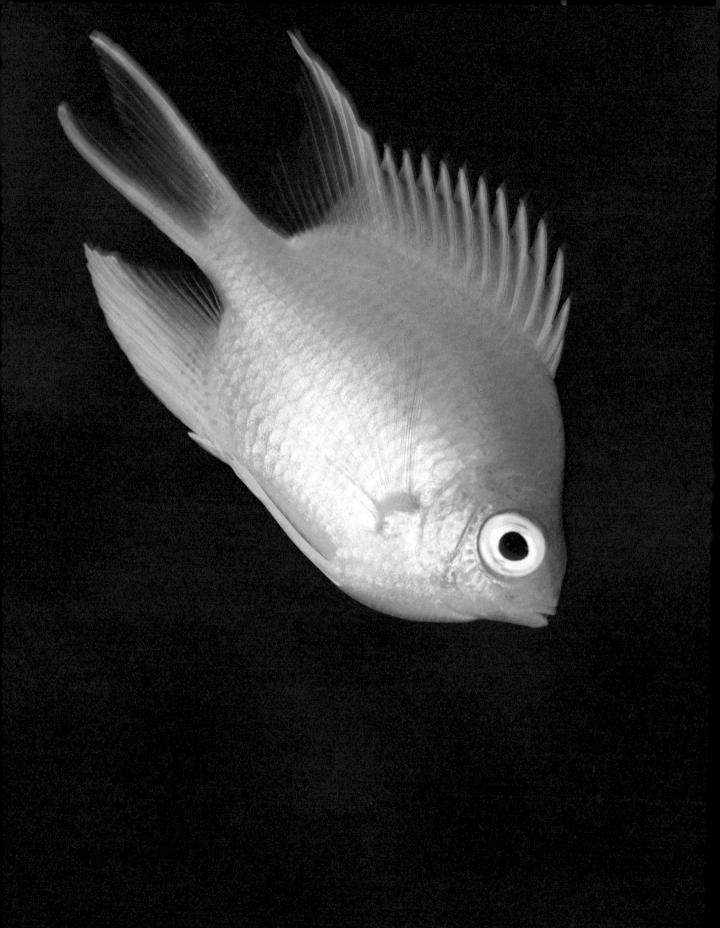

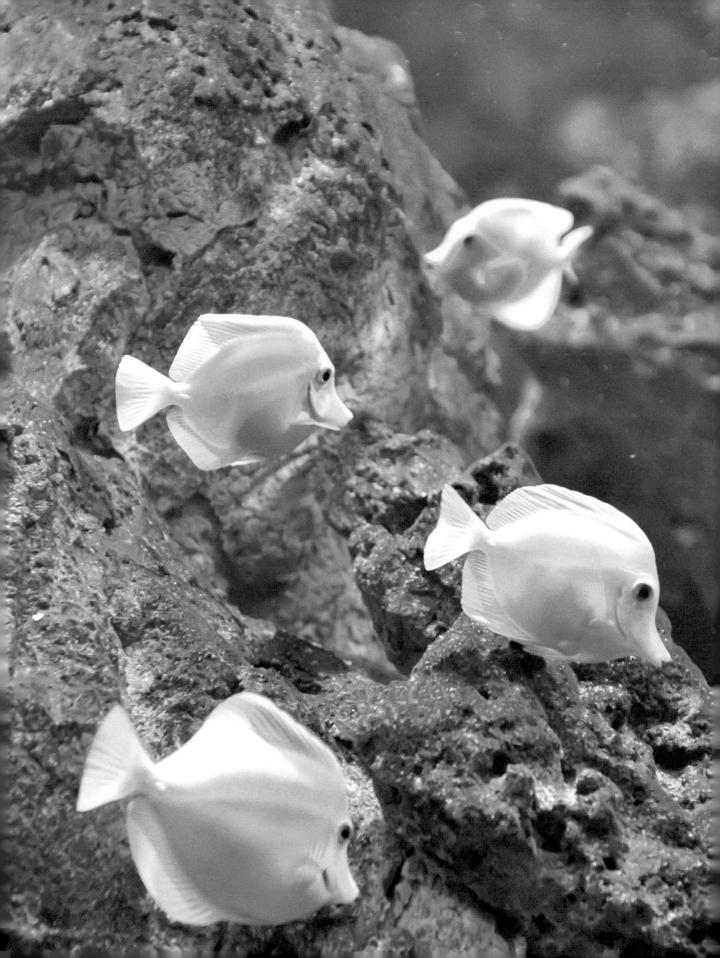

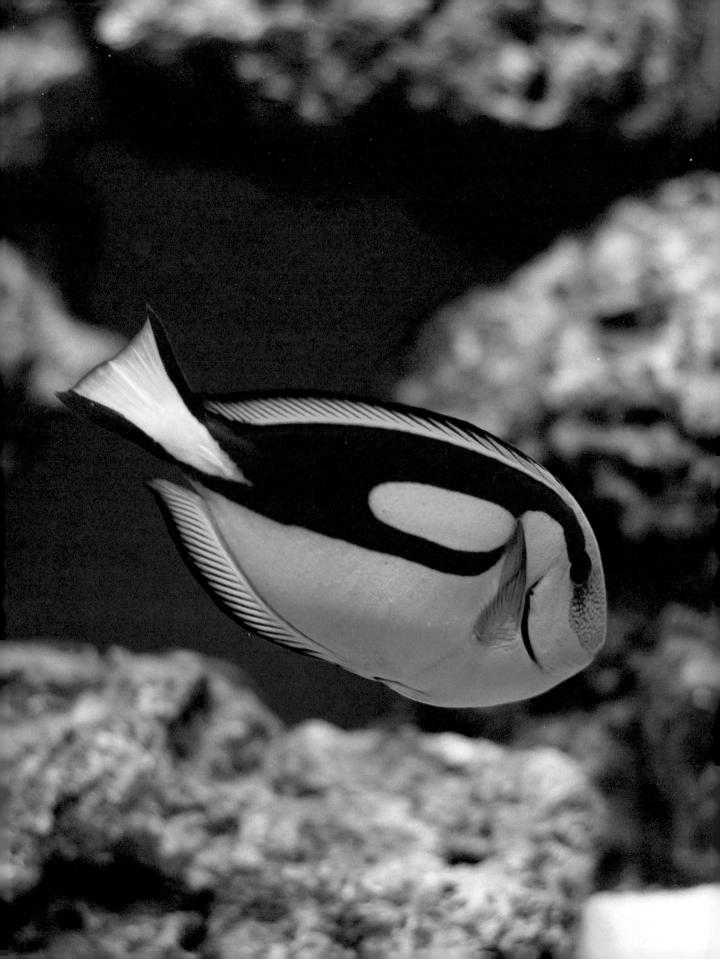

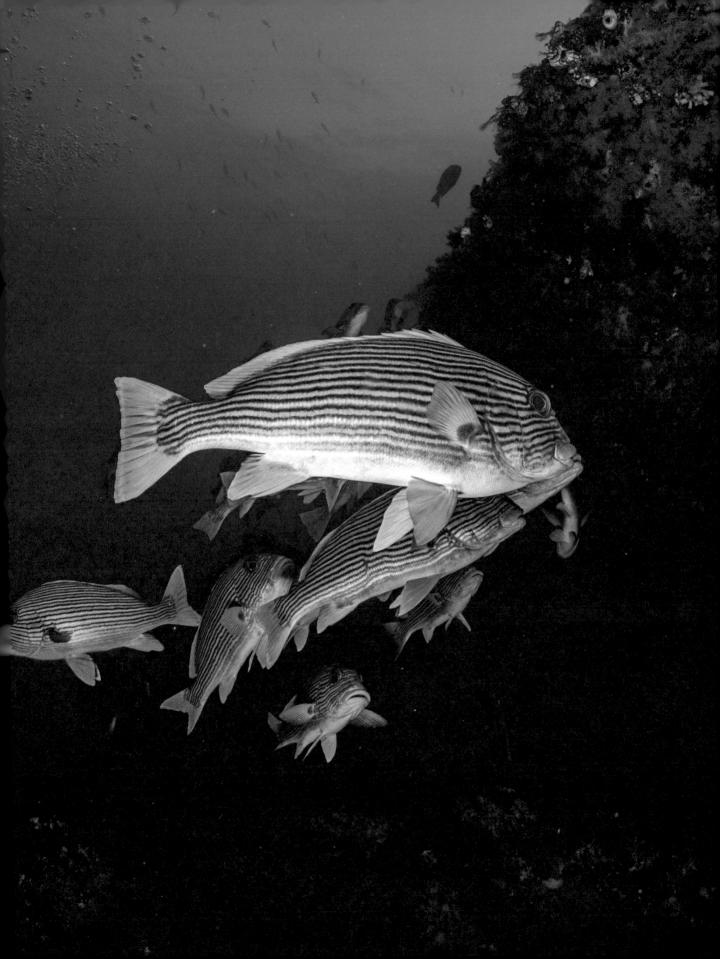

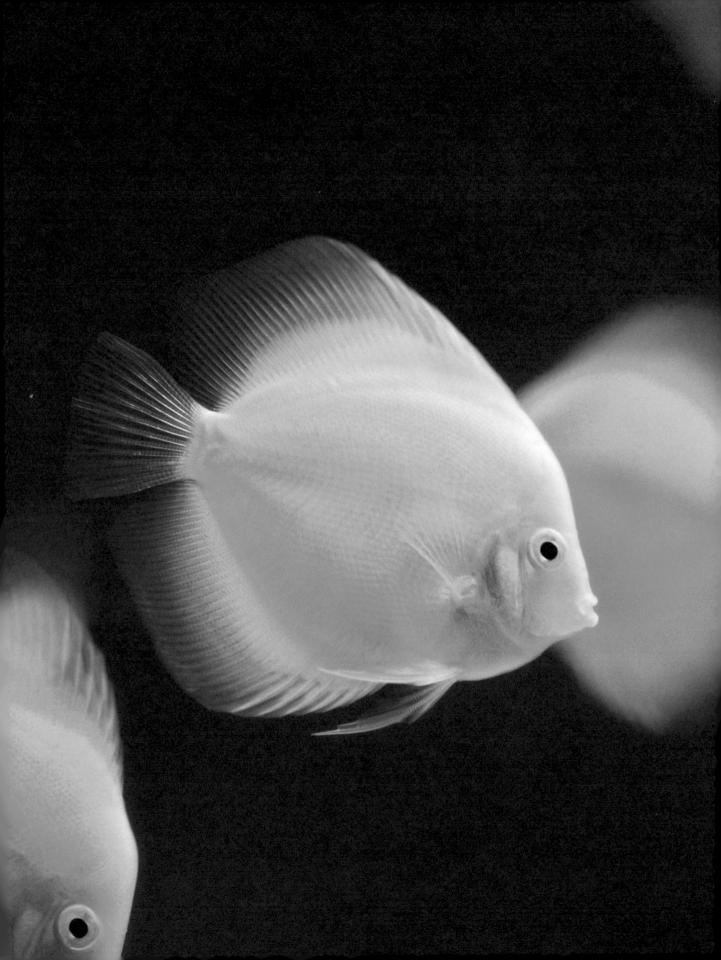

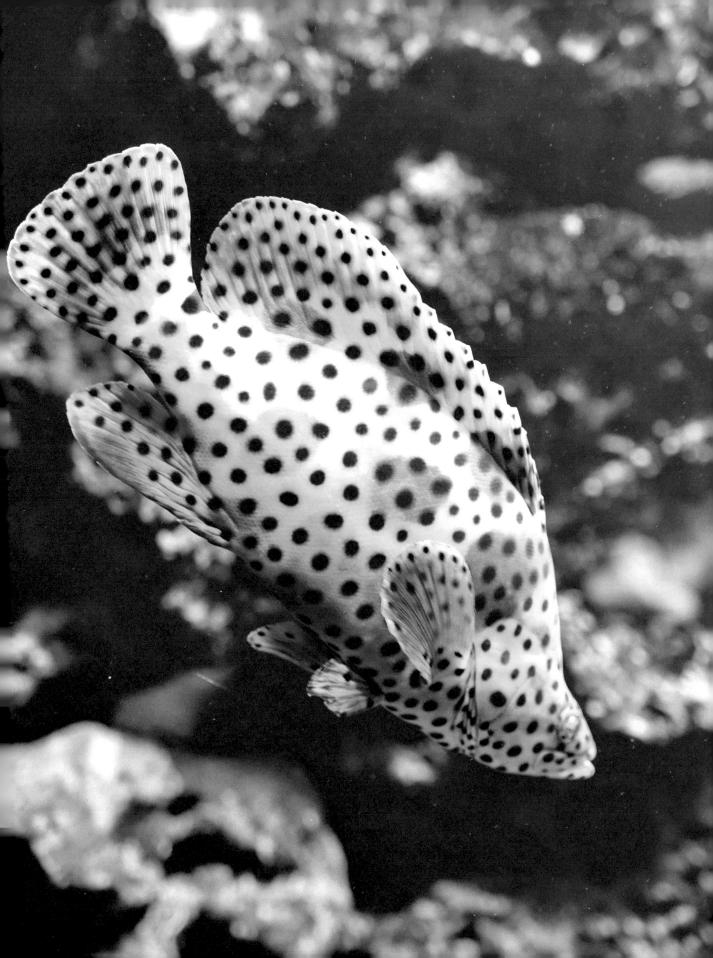

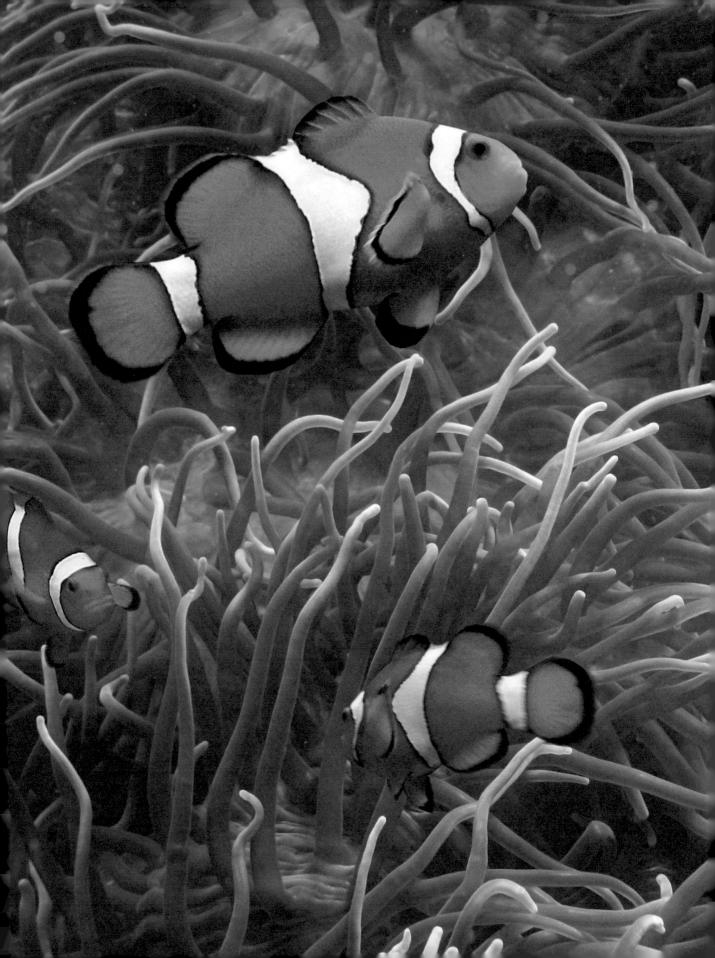

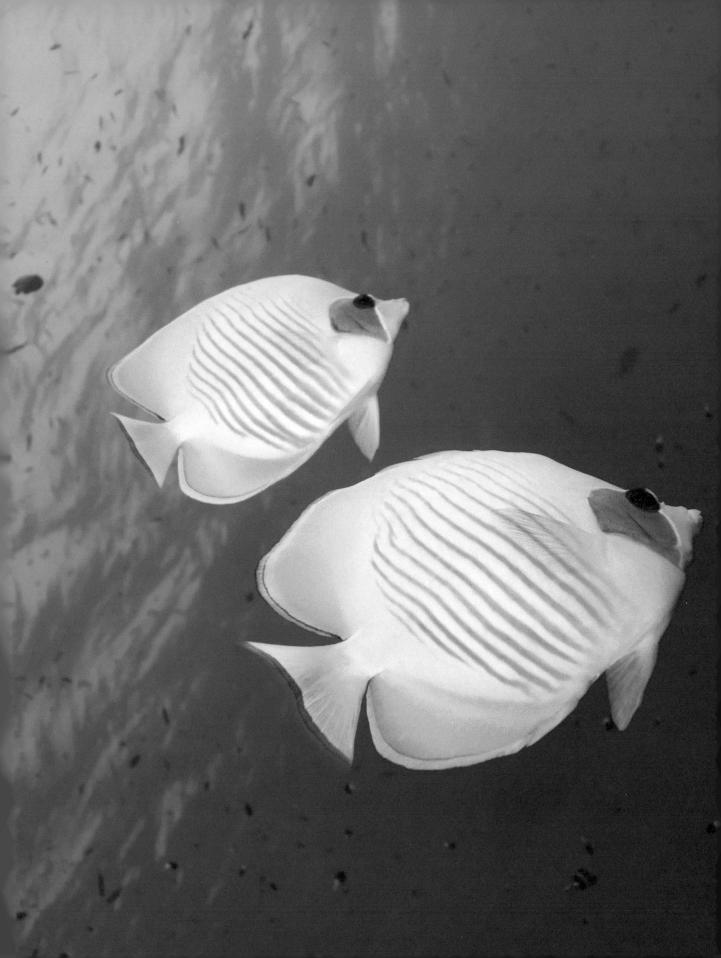

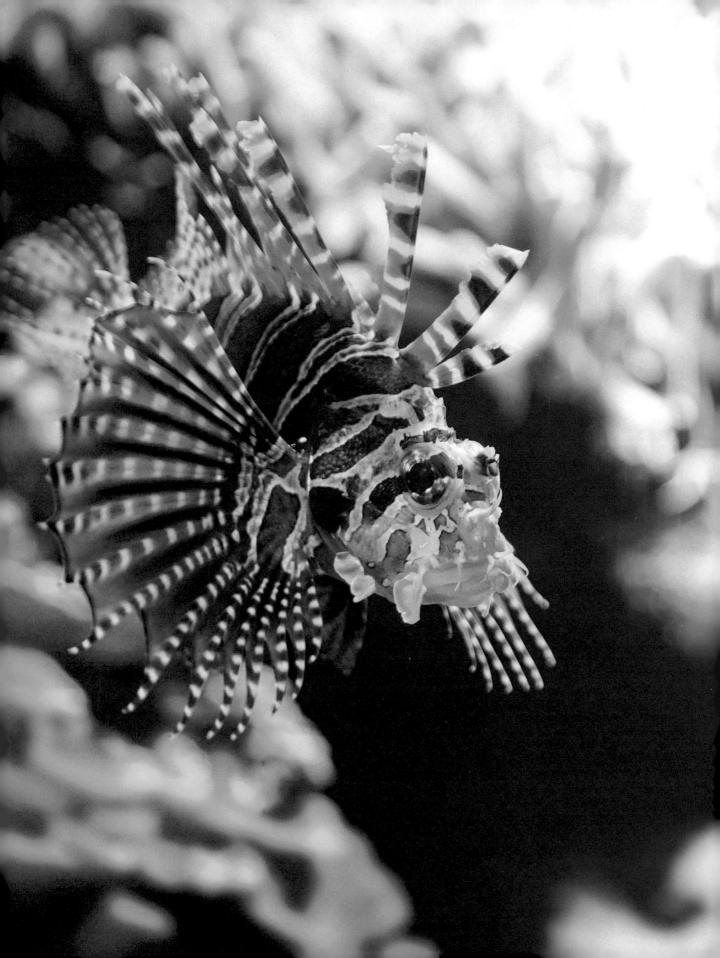

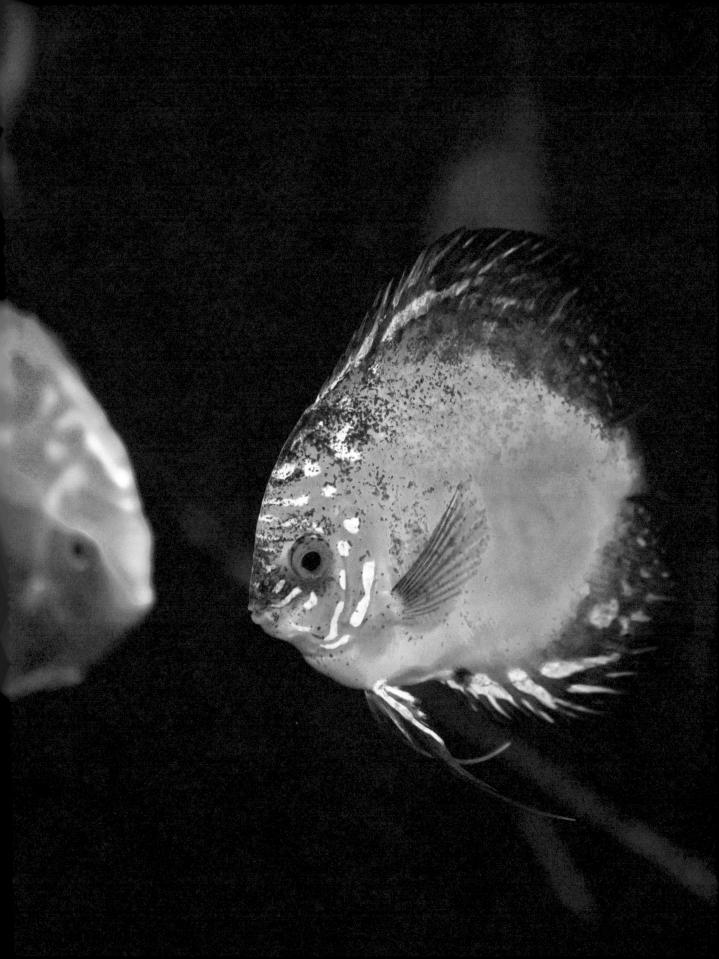

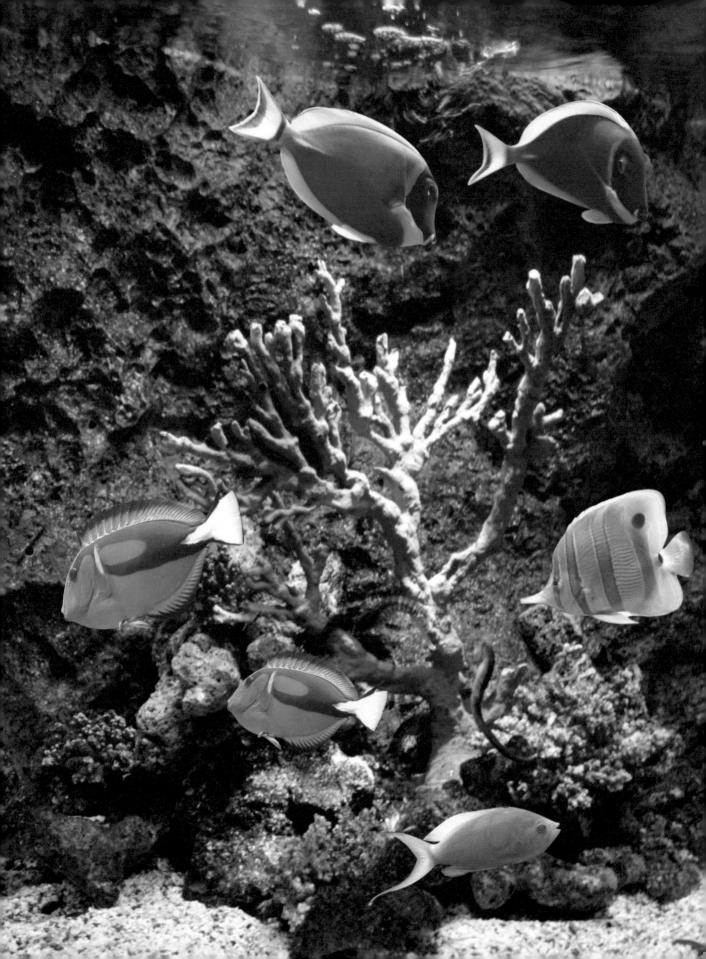

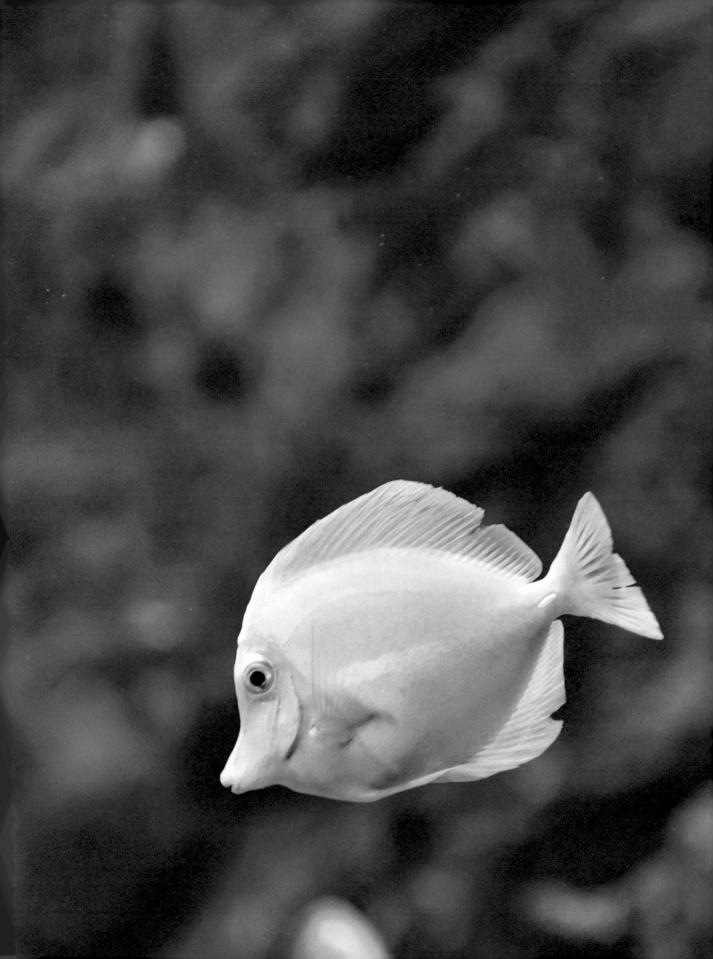

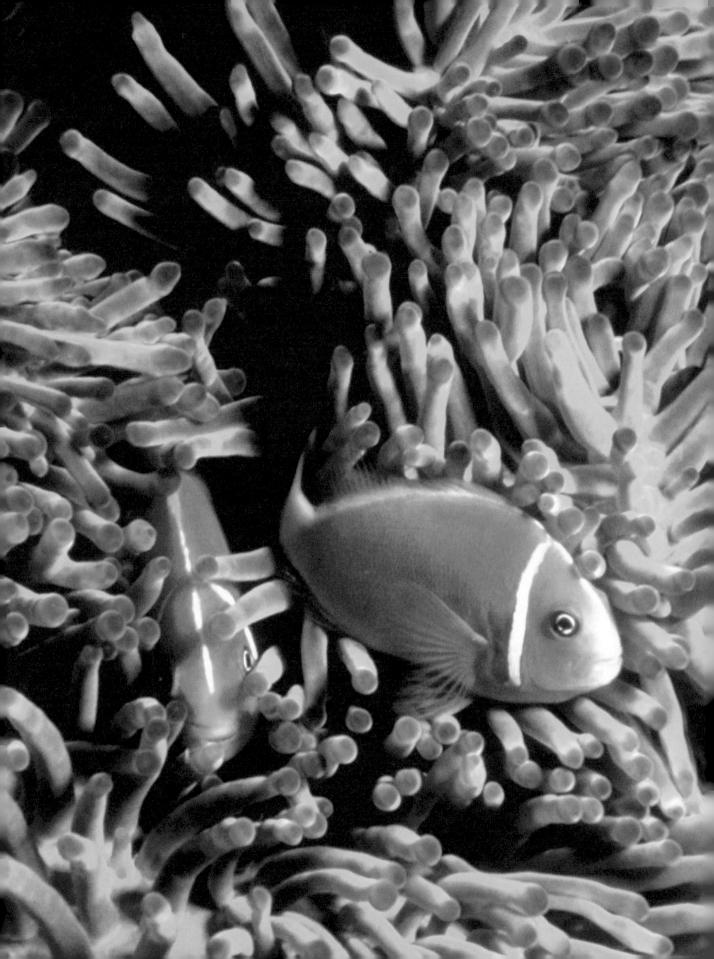

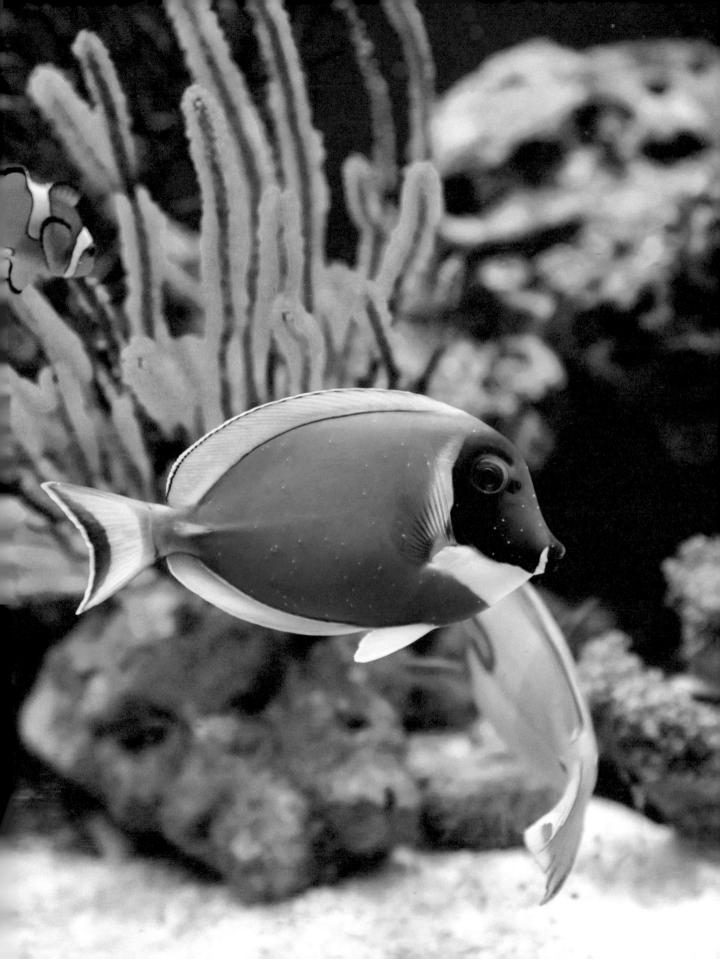

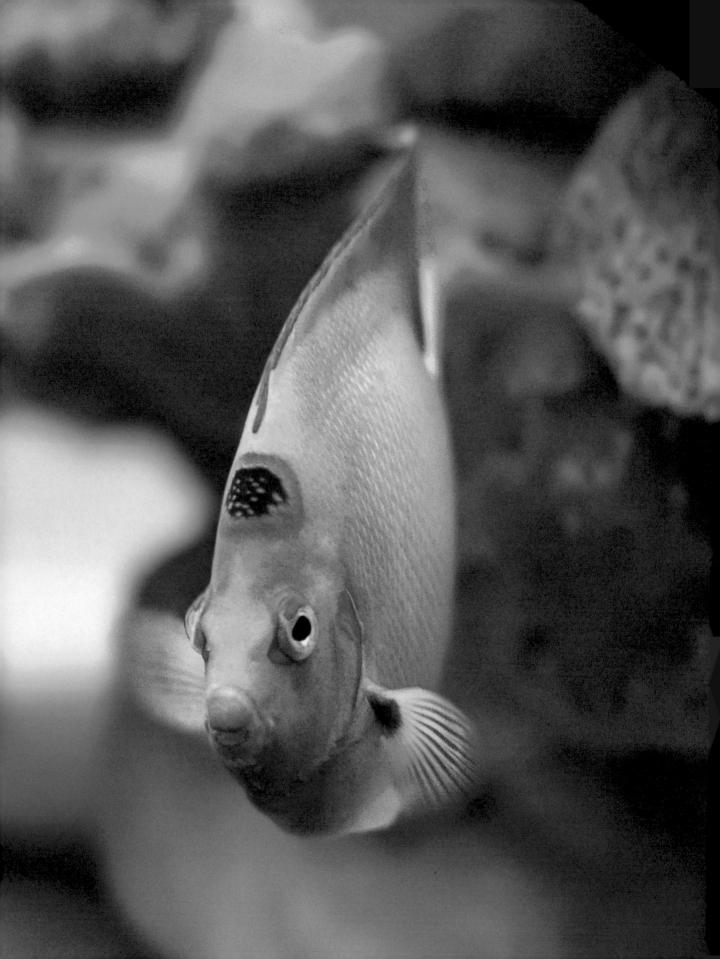

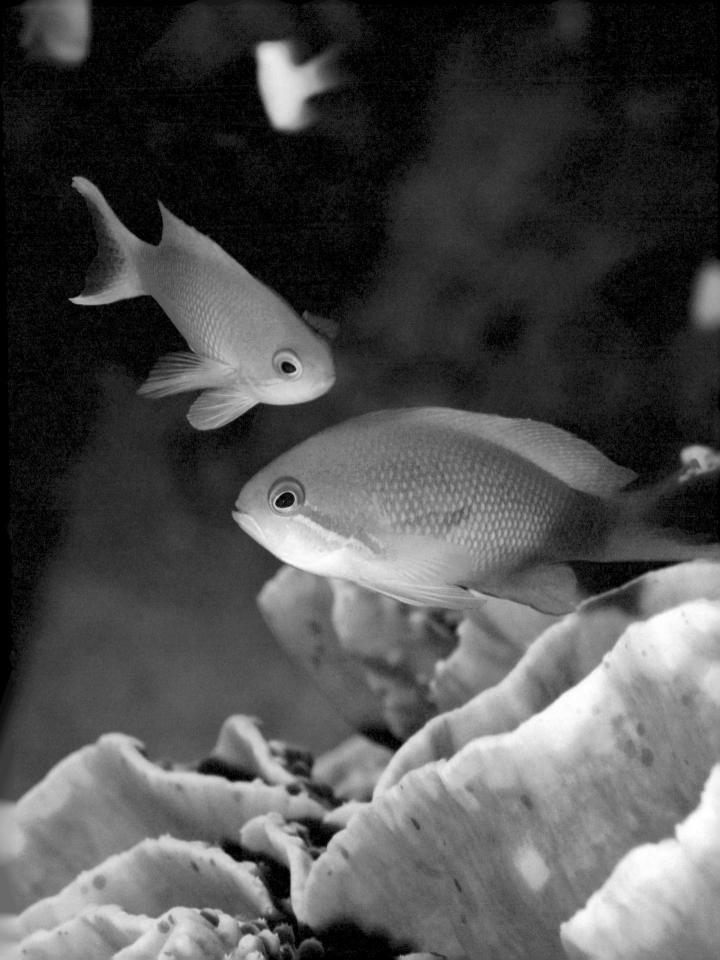

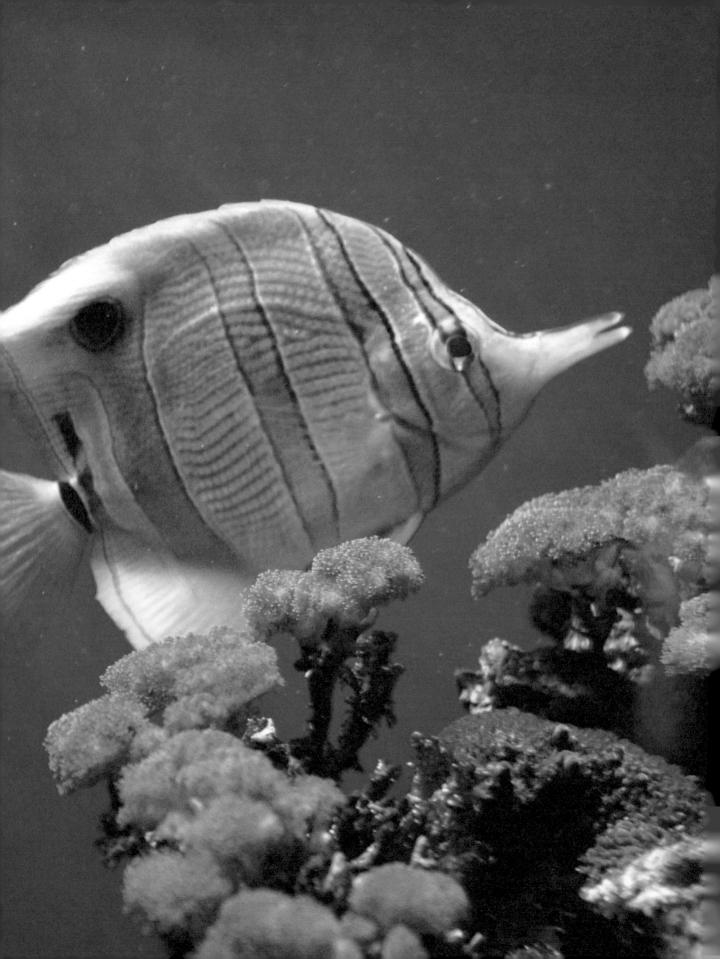

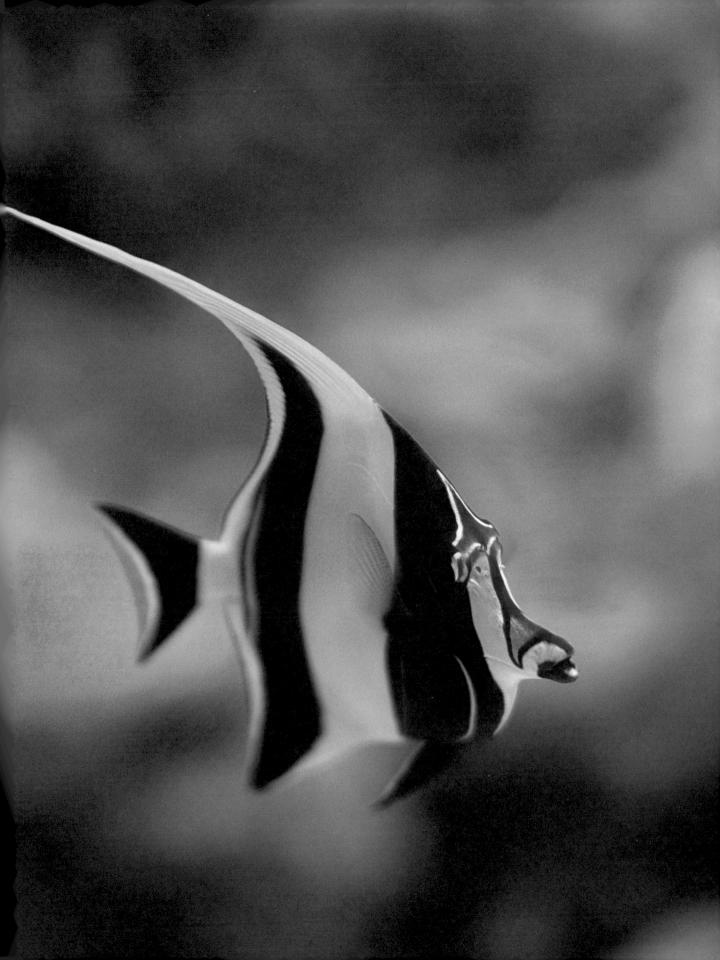

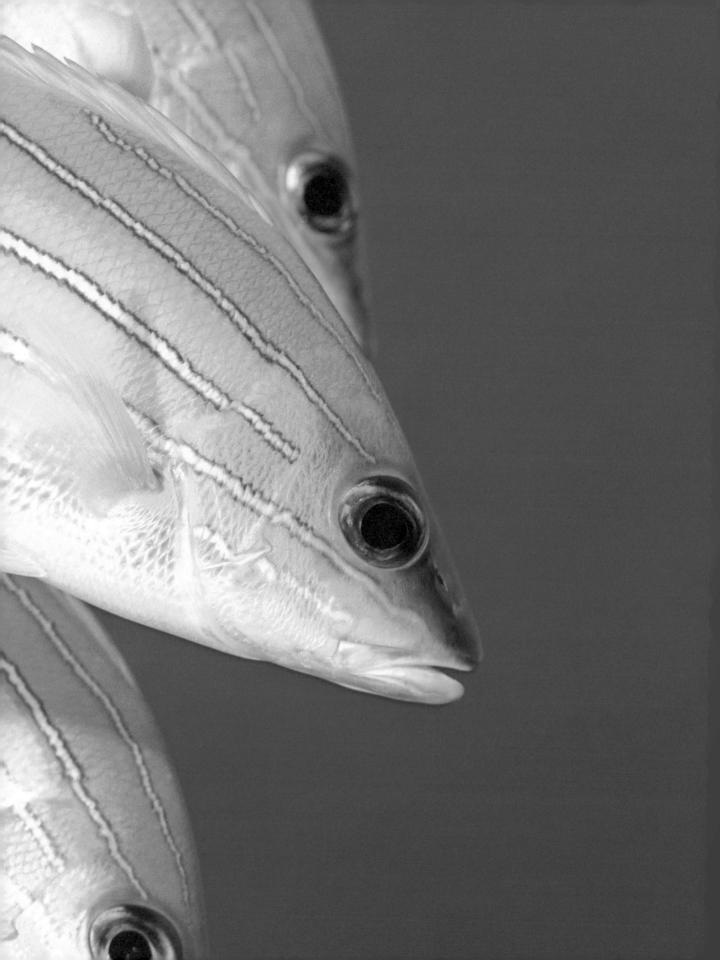

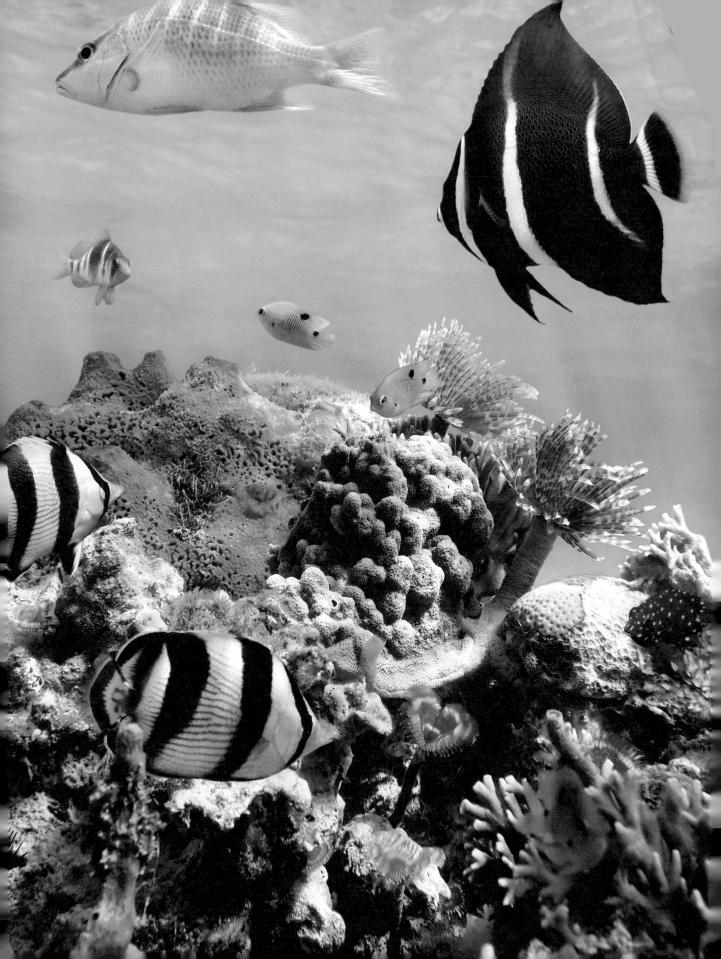

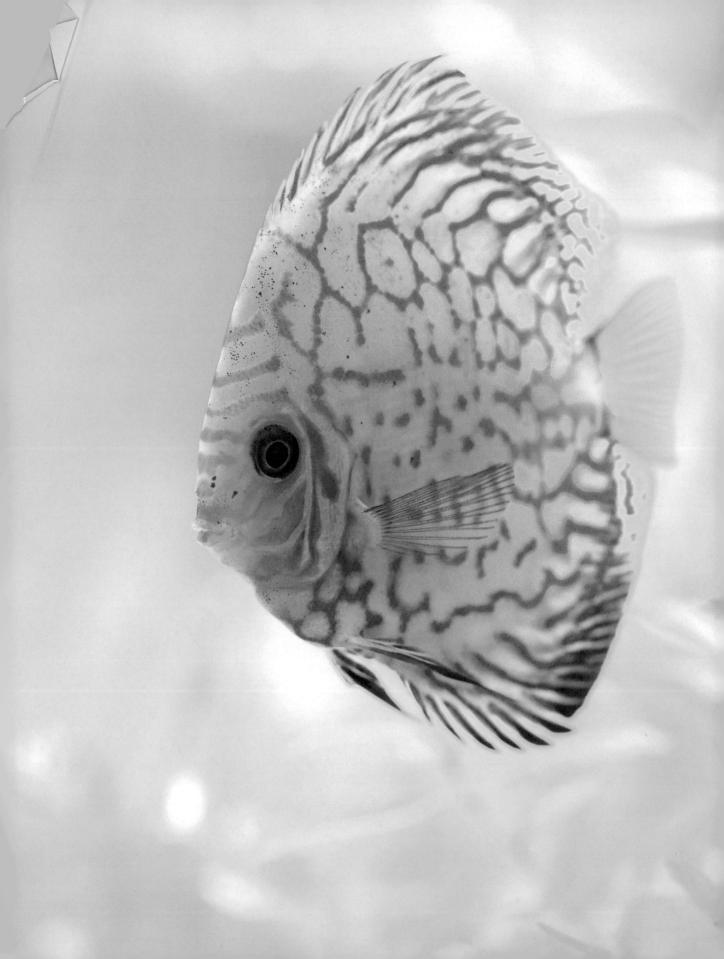

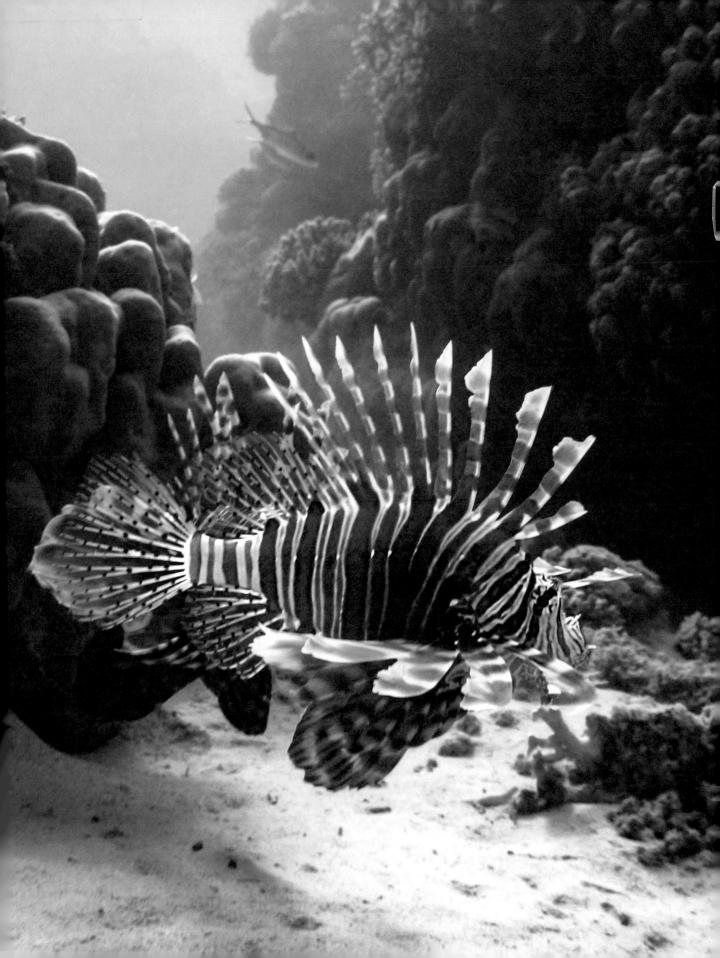

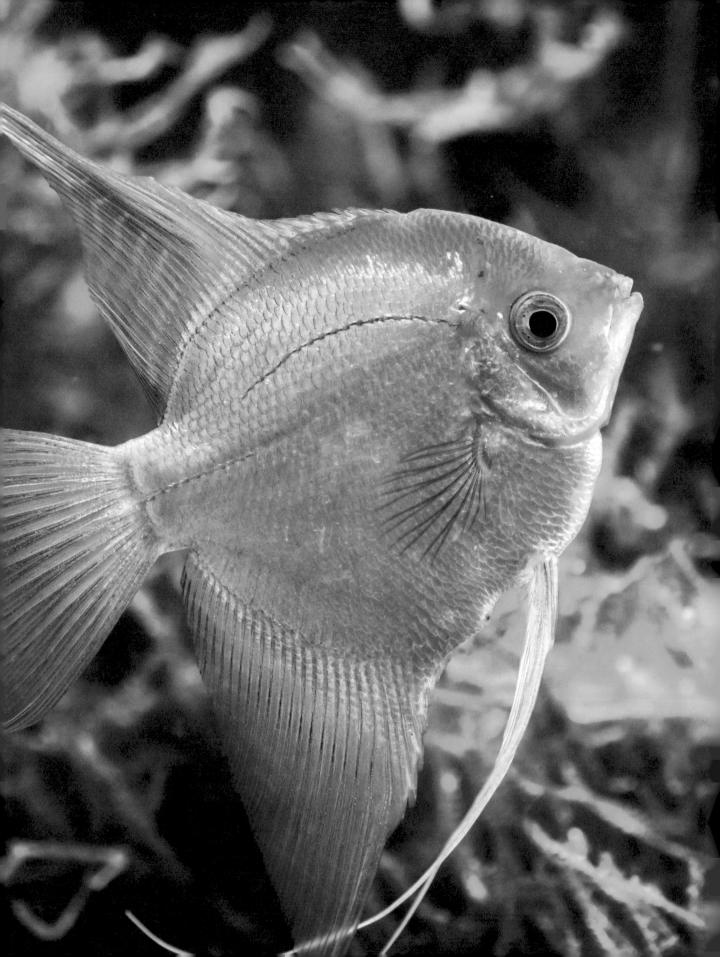

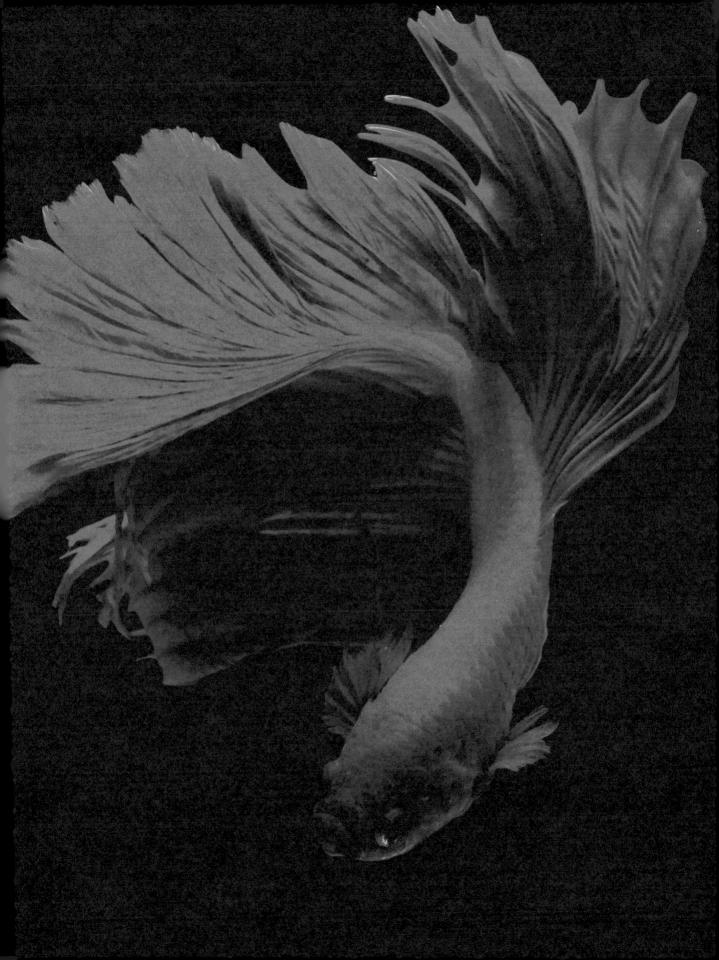

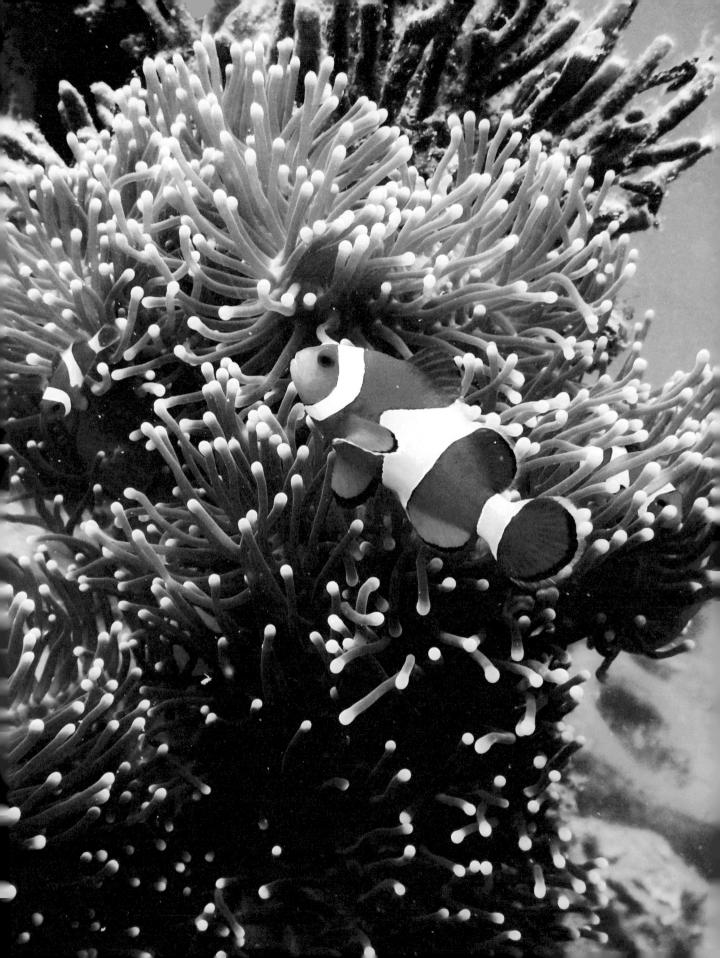

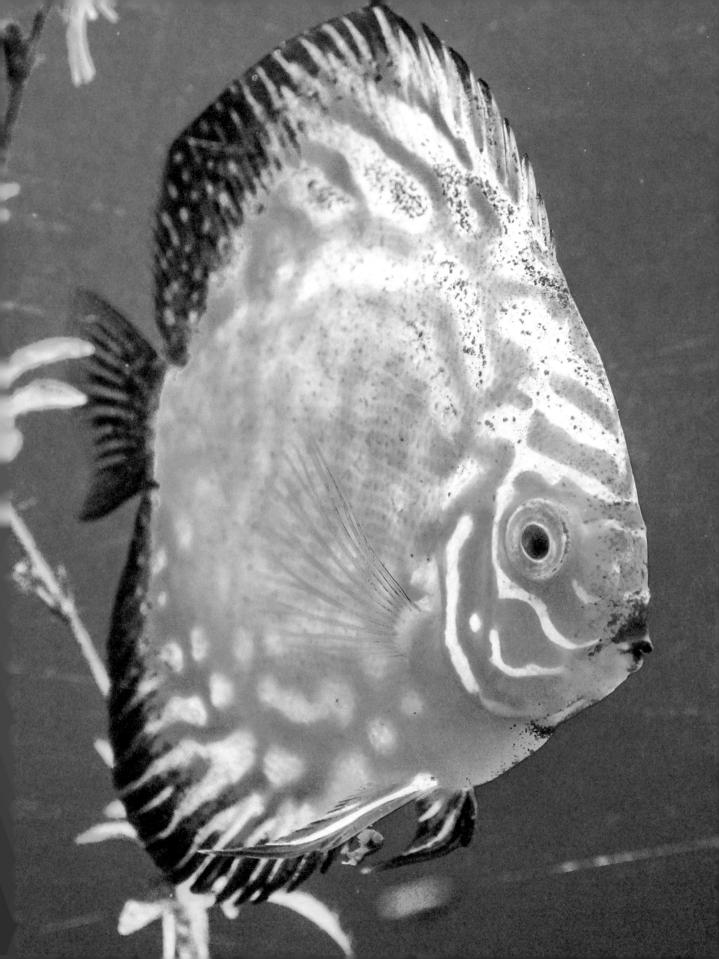

Made in the USA Columbia, SC 21 November 2024

47270302R00024